MANY MOONS

Alice Birch

MANY MOONS

OBERON BOOKS
LONDON

WWW.OBERONBOOKS.COM

First published in 2011 by Oberon Books Ltd
521 Caledonian Road, London N7 9RH
Tel: +44 (0) 20 7607 3637 / Fax: +44 (0) 20 7607 3629
e-mail: info@oberonbooks.com
www.oberonbooks.com

Reprinted in 2011, 2012, 2013

A catalogue record for this book is available from the British
Library.

PB ISBN: 978-1-84943-077-7
E ISBN: 978-1-84943-559-8

Cover image: London at night as seen from the International
Space Station.

Photo Credit: ISS Crew, Earth Sciences and Image Analysis Lab,
JSC, NASA

Printed, bound and converted
by CPI Group (UK) Ltd, Croydon, CR0 4YY.

Visit www.oberonbooks.com to read more about all our books
and to buy them. You will also find features, author interviews and
news of any author events, and you can sign up for e-newsletters
so that you're always first to hear about our new releases.

For Dad and for Tony

I'd like to thank everyone at Theatre503, particularly the brilliant
Derek Bond, Sophie Watson, James Perkins, Sally Ferguson,
Tim Roseman and Paul Robinson. Special thanks to Circles UK,
Giles Smart, Stephen Hanvey, the McQuillans, Jude Christian,
Lola Stephenson, Simon Stephens, David Eldridge and everyone
who read the play out loud and in their heads. Thanks to my
wonderful friends and family, to Mum, Tony, Rosa, Alice, Geej,
Dad, the real Juniper for lending her lovely name and as ever and
always: to Nic.

Characters

MEG
Resigned. 42.

OLLIE
Falling. 26.

JUNIPER
Hopeful. 24.

ROBERT
Shy. 63.

1

2

3

The parts of 1, 2 and 3 can be read by the actors, or projected as the director sees fit. Only four actors should be used in total.

/ Denotes the overlapping of speech

… Indicates the character cannot express what they are thinking

The spacing of the dialogue and the use of upper and lower case letters are there to help the actor in terms of pace or weight of their words.

18th July. Stoke Newington, London.

Many Moons by Alice Birch was first performed at Theatre503 on May 17th 2011

Presented by Theatre503, Sophie Watson and paper/scissors/stone

Original cast:

OLLIE, Edward Franklin
MEG, Esther Hall
ROBERT, Jonathan Newth
JUNIPER, Esther Smith

Director, Derek Bond
Design, James Perkins
Lighting Design, Sally Ferguson
Music arranged and composed by Ellis James and Benson Taylor
Stage Manger, Sophie Martin

Under artistic directors Paul Robinson and Tim Roseman, Theatre503 has become London's main and most highly considered entry-point theatre for playwrights, where they take their first public steps based purely on artistic talent and not experience or profile. As a result Theatre503 has won numerous national awards, and became the smallest theatre to ever win the Olivier Award for Best New Play.

This production was supported by the National Lottery through Arts Council England, The Mackintosh Foundation and the Williams Charitable Trust. With thanks to everyone else who helped to make this production happen.

LOTTERY FUNDED

A white room. The back wall is lit with tens, hundreds, maybe thousands of light bulbs. The play is direct address to the audience.

I.

MEG: And my Heart started to beat at 2.19 in the afternoon of the 18th of July on a pavement in Stoke Newington.

Until that point it had flatlined.

For an Entire lifetime.

II.

OLLIE: Prude, I think would be a bit far.

I'm not very

I find it quite difficult to

I've never been one of the

Lads.

I suppose.

Ahhm.

I get quite excited about constellations.

And foraging.

I am Good at

Computer Programming. Debugging, coding and compilation.

I don't really like Travel

Or too much change.

I have only owned a television for three weeks and that's because the woman who used to live here – Felicity something – left it behind and I quite like University Challenge and I don't mind Blue Planet, but I can't really get my head around much more than that – which is odd, I suppose, because Blue Planet is about an entire world and Eastenders – ah – for example, is just one street or square, as far as I can gather.

I don't drink very much – the taste isn't

I can't

Never enjoyed it. Apart from Archers

and Lemonade and that isn't something you can really order in the pub with

the aforementioned

Lads.

not that I know any Lads.

Actually.

Well, Mike, maybe, who studied Physics and was in my college, and once um relieved himself – number two – on a girl who was asleep in her bed – after too many Snakebites.

And if some of you need me to elaborate on that sentence, I can't. Really. So. I couldn't explain what a Snakebite actually is, other than it is a beverage and it does seem to get people incredibly Drunk.

I find people quite

Difficult, actually, I've never been the most

I always *wanted* to be someone

Who could

…

with people

instead of Stars and Planets and Fireworks

and

…

But it has always been beyond me.

Just out of reach.

It was on the 18th of July that my Heart began to Beat and I began to bridge that gap and be on the brink of being a real live Human because

All of a Sudden

I am in Love

MEG: I like to sit at home.

All day if I can.

There is a window seat underneath the bay windows next to the French windows which are underneath the roof windows which are like clerestory windows because the ceiling is so high that underneath you can see the whole sky and earth rolling.

To get to our kitchen you have to walk through the rest of the house and down several steps. It's nestled into the garden and is so low down that underneath the roof window on the window

seat by the bay window next to the French windows it is easy to imagine you are underneath the world looking up at footsteps.

I like to make bread in the bread maker and marmalade on the stove in a very large pan that I bought from a farm shop in a town called Tetbury which is where Prince Charles has his Duchy estate and when it is ready I eat the marmalade on the bread which I cut into very thin strips that I call farmers because my parents were pacifists and didn't say soldiers.

I like to eat half of the homemade bread and marmalade farmers and then throw the other half into the compost bins at the end of the garden.

I found a dead rabbit in my compost bin once.

Pulled it out by the ears.

Made a tear near its rectum.

Put my hand inside and all the way up through its once warm stomach and intestines and little heart and neck and into its open mouth.

Like a little doll.

In the mornings I like to go on Facebook on YouTube on Hotmail and Gmail and Mumsnet and Bebo and MySpace with Jeremy Kyle and then *Woman's Hour* and *Loose Women* in the background and then perhaps *X Factor* or *Take Me Out* or *Strictly Come Dancing* repeats. I like to read *Anna Karenina* and *Madame Bovary* back in the window seat and eat half of a peach or half a nectarine or half a greengage if they're in season, but never lychees, with Chopin or Debussy or Katie Perry at full volume, depending on my mood.

I have waited my Entire Life for it to begin.

For something to happen.

Like it does in the books or the poems or the films or in other people.

For the Goosebumps or the Tears, the Stomach Flips or the Grief in your Heart which for me only seems to lie nearly dormant.

Did you know that if you have never felt anything close to love or fear or excitement or rage that your heart can get by on four beats a minute?

JUNIPER: I am Looking for Love. I am Actively, looking for Love.

You know those traffic light parties where you wear red if you're not available, amber if you might be and green if you absolutely are? Well I'm on green. Constantly.

I sometimes think my Heart will fall Out of my ribcage and land at my feet, the pace at which it beats.

I like a lot of things – I *love* a lot of things. I get excited pretty easily about food and friends and parties and events and the weather and sex and films and just hanging out.

I like Facebook a lot – I have it as an app on my iPhone which I sort of hate, because I like to think of myself as quite an arty kind of person – a bit of a free spirit, even, which is so cheesy but if you knew me you wouldn't think it was so bleugh, you know? I'm a bit cartwheely, a bit sort of out there, you know? I sometimes just get on a train to wherever without buying a ticket and just chat away to whoever I'm next to.

I'd say I was a feminist – but probably not in front of a boyfriend. Not that sexy really, is it? I want to do a bit more, maybe volunteer – there's a shelter not far from me for women and I think I'd be good at that because I am very good at empathising with people. Really. I cry at everything. There was a single mum on *X Factor* with really low self esteem and she had a beautiful voice – a pretty good voice actually – she had a voice – and I just sobbed because I really *felt* for her, you know?

I was going to go on the Reclaim the Night March last year but it was so rainy and there was this Chav Night at this amazing bar in Dalston that I didn't want to miss because there was this boy – but. Anyway. It is an annual thing and I will Definitely go next year, in the diary – I have a five-year diary big pink circle around it.

I have been told I smile a lot. I was once told my smile was my best feature – my bottom is my worst, I know – and I do like to smile. I read somewhere – Glamour, I think – that smiling is statistically proven to be more attractive than makeup…which now I say it out loud sounds ridiculous – I'm not sure how you're supposed to come up with *statistics* for that, but –

Mum worries that I'm not safe – a lot. That I'm too friendly. When I told her I was moving to London she sent me three rape

alarms and some mace, which she said was actually surprisingly easy to get hold of once you've figured out how to use Google, when I called her to ask her why she was sending me illegal goods.

I'd never do online dating – you do hear horror stories – and it's so horribly *un*romantic, but I did once put an ad on um Dalston Dating dot com. Just to see. You have to come up with a name and a little um tagline – I had 'Insert something witty here' and got a whole load of cock jokes, so had to start again.

Small Brummie Smiler seeks Man with Hands that might be good at Holding my Hand. For Walks, Kisses and Cook-offs. Must be tall enough to rest your chin upon my head. Tolerance of kind-of feminists into Eighties pop, potatoes and legwarmers essential. Good voice for reading stories out loud is a bonus. Knowledge of stars – clincher.

I have mapped out the heavens through the constellations with those glow in the dark stars on every bedroom ceiling I've had since I was eight.

Still seeking.

ROBERT: There have been times in my life when I have looked at Bridges and Canals, Seas and Light fittings, Rivers and Shower Rails and Heights differently.

I think that Life is Astonishing.

Really.

Completely

Breath

taking.

Literally, I suppose.

I think I'm doing a full circle.

As a child I was curious.

I liked Knowing Things, I liked being called a 'Know-it-all'.

And, I am the same now.

Which is nice – I think it's nice.

To stop and take breath sometimes and to

Every three days the stomach gets a New Lining.

Which is sort of Fantastic, really.

I like Tea more than almost anything else and I genuinely believe it helps to make things better.

When killer whales travel in groups they breathe in unison.

Which is what my wife and I do.

My little killer whale… She has never really. Cared for that.

No piece of paper can be folded in half more than seven times. I'm serious.

Try it.

Amazing.

And I am in possession of the greatest kind of love.

We –

she'd hate it if I was talking about her –

– We kissed at traffic lights. I know the lines upon her hand. The little bumps and soft fat upon her stomach. Her smell in the morning. Real intimacy.

And the reason my Heart is steady.

Rabbits are incapable of vomiting.

But there are Times when

The main blood vessel in a blue whale –

No. There are Times When

Life is So Astonishing, so Utterly Overwhelming, so entirely

that it's hard to

It's hard to.

It becomes harder to.

The main blood vessel in a blue whale is big enough for a human to crawl through.

The sun is 330 330 times larger than the earth.

My Heart is Steady. Always has been.

III.

MEG: It's the 18th of July today. The 18th of July.

We – Michael and I – have separate bedrooms now because I wake up at 3am most mornings and I am not a quiet sort of a person.

We also have separate bedrooms because Michael snores.

And sweats.

And I bleed.

And vomit.

And he shits himself.

And I have this head poking out between my legs, occasionally asking questions or shouting 'Mummy' which he finds a little Unnerving.

And

I suppose that we lack that Intimacy that we had when we were. No.

That he and his secretaries had when they were.

No. That he imagines he has with this Woman he sees in Islington on a Saturday.

(Whispers.) Who he pays.

To see. On a Saturday.

But it is *nice*, it is much nicer to say that we have separate rooms because I am an early riser and up with the cuckoos and the dew and the dawn.

And today is the 18th of July.

Which means I can cross off the 17th of July on the calendar and think about the balloons that are scrawled on the 18th.

It's going to be hot. I can feel it in the nape of my neck, which is already dimpling, and the underside of my swollen belly, which is already warm and a little damp in anticipation for heat to come.

The budleia is stretching itself over the windows at the front and back of the house. There's ivy underneath that's ruining the redbrick but it looks too pretty to touch and Michael put a rake through his foot when he was ten and doesn't go into gardens, save to get to tarmac and pavements and car parks now, so if it does eat through the bricks and into the belly of the house and all of the custom-made beige and white and wood

He can hardly blame me.

I cross off the 17th of July. Just like I cross off each day in the black fine-liners that we keep in the ceramic pot from his mother's trip to Skiathos. It fits just behind the one Le Creuset dish I have never used by the Aga. So no one has to see it.

It has cats on.

And I am Very allergic

to Michael's mother.

I might prune the budleia later.

On the radio they're talking about another Missing Girl. She's young. It's about sex probably. Which has always made more sense to me than it should – missing girls are always young, only a psychopath would want to fuck a granny.

I can say that because I have a little girl and I am a Mother.

It's already light, so I put Michael's loafers on that are by the back doormat, next to my shoes and Flora's little red wellies, and go out into the garden which is positively jungle-like at the moment. The wildflowers are in bloom and I like to let the daisies and the grass grow tall. It tickles at my ankles which are bare which is when I realise my legs are bare and my pale red nightgown is thin and damp where it caught on the green by the door which is when I notice the Hay moon has made everything appear half there and a yellowing violet. Which is when I notice the man. The boy? The man (?)

By the fence.

By the fence at the back of my garden.

By the fence at the back of my garden. Looking up.

ROBERT: Mornings begin with I love yous.

Blind and one side now.

Mornings have always been my favourite part of the day.

The reasons have changed over the years but lately it's because June sleeps late now and I can sit on my own and just sort of Be.

Which feels like a luxury because it is one.

This morning is different.

Because this morning I have to do something, I have to ready myself to do something that I don't want to do. That I know I have to do. That I do want to do. But that I don't want to do.

I didn't sleep well – I don't sleep well.

Fits and starts, deep and light and I wake up headached all over and

It's 6am. And I have four hours until I have to leave the house on my own this time. A nurse, Holly, because it is a Saturday, will come to sit with June whilst I am out. Holly is a comfort. Holly doesn't like me. She doesn't say a great deal to me, but she does come and lots of the nurses won't even come to us. But she does. She treats June like a human. With dignity and respect. Which I like. And I don't mind that she treats me like less than a dog. Like an inanimate object. I don't blame her. It's Important to recognise that people have that right. And though she doesn't talk to me she doesn't talk about me which I am grateful for.

I have a Circle.

And they say that I am a Person.

I am a Registered Person.

A Registered Citizen.

A Registered Carer.

.

A Registered Driver.

A Registered Tenant.

A Registered Person.

The Carer is in some ways the more difficult.

'Carer is a Good Label', says Beth from my Circle. 'It is Good for You.'

I am June's Carer and she is my Cared for. As if before this

Horrible Attack

on our World

I did not care for Her and She did not Care for me.

As if it took a massive bout of Parkinson's and for her to almost disappear for the World to decide that we Care.

Good for me?

OLLIE: I stay up late but I am an early riser.

I like to stay up to watch the stars and as it turns into the 18th of July I am outside watching white dwarfs in the heavens. White dwarfs are the final evolutionary stage of a star with a mass not high enough to reach supernova and they are quite beautiful.

I don't sleep.

Not as in generally – I mean, I sleep, in fact I am a *deep* sleeper, which is lucky because my neighbours are loud.

Loud arguments, loud parties,

loud sex.

But last night I didn't sleep until very late – later than usual.

I want to be good with people.

I once put a note under the door saying that if they were going to be noisy, perhaps they could have invited me over instead of leaving me feeling so

Disturbed but this must have been misunderstood.

Perhaps they thought I meant invite me over for the sex, not the parties.

It had taken three Archers and Lemonades to write that note.

I live on my own in a flat set back from Manor Road in Stoke Newington. I quite like it here.

As much as I have ever really liked anywhere. I chose it because the rent was cheap. Ish. And because it was the first place I looked at and I find that kind of

Human Interaction

Difficult.

When I was at Oxford, Susan – my mother – came to visit me. She wanted to see everything, to go and look at Things. Like shops and parks and buildings.

I showed her my rooms and the labs on Keble Road.

I showed her my walk there and back and the Sainsbury's on Magdalen Street where I did my shopping.

She nearly toppled over when she saw the Bodleian Library.

It hadn't occurred to me to show it to her, we passed it on our way to Bella Italia, and her knees bent double and she made a little noise and her skirt billowed. I spent my days studying Galaxy Dynamics and Stellar Evolution, supernova explosions and the physics of stars and the Entire Universe actually and Susan was buckling at a building.

The morning of the 18th feels a little different.

It feels a little different because of Last Night which I don't want to think about, actually, I don't want to think about

that. Thanks.

It is hotter than it has been all summer and my flat smells a bit like sour milk. I suspect it has done for a while and so I don't really notice it too much anymore. I have rotas for when to do my washing and what to eat on each day because I ahm I tend to forget if not. Today is toast with beans and a poached egg – which is the one thing I can actually properly cook. Which makes Susan worry I will never be able to *woo a girl.*

I want to be Good with people. I really do, I'm just not sure how.

I stood in a queue in Pret a Manger the other day and the woman behind the till served four people behind me. I had to step directly in front of her face – too close to her face – close enough to see the hairs above her lip – and she asked me what I want. Conductors on trains forget to check my ticket. When I got my undergraduate degree half of my professors didn't know who I was, I don't have the kind of face that people notice – more than notice,

register, even.

I would like to

woo

a girl – I would. I would.

I would like a…

Partner. Girlfriend.

The neighbours are quiet this morning. The walls are thin so I can sort of hear one of them crying or laughing perhaps. I think it might be the Northern one –

I think she's Northern. I am not good with accents.

She smiles a lot. A lot.

Says hello sometimes. I think she must be quite pretty. Her name's Juniper Jessops, I've seen it on their post, which is just about the most mental name I've ever heard of. But she seems a bit mental. A bit magic.

JUNIPER: Today

is my Birthday.

Which is quite a huge deal. Actually.

Birthdays have always been a huge huge thing in our family – I have a big family and I'm the baby so I've always had a bit of a

fuss made of me. And I sort of wanted to go home this year, but Mum had already booked a holiday and I couldn't get hold of Sasha or Honoria and Isaac is on some retreat in Turkmenistan but that's fine.

My housemates – I should say flatmates now, housemates is what students say and I am a working girl – God, not that kind of working girl, I work in a doctors' surgery – which is great, but I'm not entirely sure it's what I want to do with my life.

I used to have this thing when I was little that I was pretty sure I'd get about six lives. Because there was so much I wanted to do, and I hate that everyone always asks 'what do you do' as though it *defines* you, and whenever I'm asked I always say 'well, I work in a doctors' surgery, but actually I'd make a really good barrister, thanks.'

Dad's a surgeon. I might end up doing that. But I think I could act – a bit – well, I want to be in black and white movies, really. And sometimes I think I should teach. But mostly, I'm fairly sure I'd make a fantastic Russian princess. It's something about all that fur you get to wear and smoking you get to do. Do they have princesses in Russia anymore?

But my flatmates are out when I wake up and so I have a birthday breakfast on my own and a bit of a cry – which is fine because I am a crier – and a firm believer that it is good for you. It is Cathartic.

Anyway, the girls have left cards and we are going to have a party tonight so I feel better and Mum and Dad have sent a big parcel of jumpers and notebooks and poetry and *Wolf Hall* which I actually already have a copy of. I have tried to read it, because you should, shouldn't you, it won that big prize, the Orange – no, the Booker, but it is so dense and I'm not sure I'm all that interested in Thomas or Oliver Cromwell anyway. I think that I might give a copy to a charity shop, that might be a nice thing to do today on my birthday. I'll be a little bit like the March girls in *Little Women* giving away their Christmas breakfast to the poor. I tried to do that once, tried to let Mum give my Christmas brioche – we have brioche ever year – to the homeless, but she wasn't having any of it – but *I* was so determined and when I went onto the street with my bundle of brioche rolls wrapped

in a gingham cloth I could only find normal people. I ended up giving it to these quite drunk teenagers who threw it at a pigeon. Luckily Mum had spare so I still got my breakfast, but maybe giving away my birthday book to a proper organisation will work better.

People say that London is unfriendly but I just haven't experienced that at all. I do smile a lot and I think people smile back. Millie – my housemate – flatmate – says it's because I only wear short skirts and dresses (I don't have the bottom for jeans) and I do love dresses but I believe in the inherent goodness in people. I believe in unicorns and Jesus as well and people think I'm daft enough for that, but the good nature, the good heart and good soul of humankind is something I am immovable on. Why wouldn't you believe in unicorns and Jesus? This amazing man in the sky who's like everyone's Dad and who's always looking out for us. And that means death – which is just a horrible thought – that means death isn't real and that white magical ponies exist and I think that's lovely.

MEG: My husband thinks I am a fantasist.

He thinks I make things up. That I hallucinate. That the four babies we lost after Flora were phantom pregnancies. That I like to Lounge around in bed sheets weeping for babies that were never there in the first place to make myself feel more like a woman.

When I tell him at breakfast that morning that I am half-sure that there was a half-there man with half-moon eyes in our garden he barely moves.

He holds his spoon – his very specific cereal spoon – very far back between his middle finger and his thumb

and suspends it in mid-air for a moment.

He has an incredibly weak chin, meaning his entire profile is lacking.

I remember looking sideways at him during our wedding ceremony and feeling an overwhelming sense of disappointment at his feeble profile and thinking of strong jaws.

He has a cornflake on his weak chin. How it found anywhere to land on his flat face I don't know. And the whole milk is making

rings around his pink smacking lips. I realise he is quite fat in the face. I juice some more oranges for him in the White Zumex juicer that cost £1449, plus VAT.

'And are you sure you weren't dreaming?'

Dreaming?

'Dreaming the half man in the garden. Perhaps?

Seems a little unlikely. You're overtired.'

I turn the juicer up. Squash his little fat face inside it. Watch his expression and his tongue turn to liquid.

He finishes his cornflakes and somewhere inside of me I almost want to say 'Don't go' but he is up and out of his chair, his spoon dropped into the bowl and he is beginning to neaten himself like a little bird. Straightening his tie and his trousers and his shirt that his secretary sends to the dry cleaners every week. I want to choke him with oranges. Stab him with all this Jamie Oliver ceramic *stuff*. Strangle him with the Ivy as I follow him out to the car.

'Don't.' He says, as though this little goodbye is nothing.

He speaks to people all day long.

Six days a week – he works on a Saturday – or at least he says he works on a Saturday.

'You have little conversations with different people all day long' I say.

Goodbye.

Curtains are twitching in those smaller houses across the road with the gravel drives lined with hideous little gnomes that I wish we didn't have to look at.

'I'll be home late.'

'I know. It's Saturday.'

ROBERT: Mornings are beginning.

Over the road, smart cars are leaving their smart houses.

The pregnant woman who never waves is kissing her husband on the cheek.

India has the most post offices in the world.

I drop the edge of the curtain. And polish my shoes.

MEG: There is a young woman going into number 68 – the house where the older couple live. It's the same girl as always – for a while I thought the man must be having an affair, or that she was their daughter. But she wears a nurse's uniform – and not one of those ones a mistress would wear – but one for practical reasons. She is terribly pretty.

The man answers his blue door that's a little chipped and lifts his hand to me.

I manage to look right the way over his little house – it isn't difficult – and pretend I haven't seen the gesture.

ROBERT: Perhaps it is London.

When I let Holly in, the pregnant woman who never waves, ignores my wave.

Holly has seen this. She reddens. Her fingers tighten to a fist.

June baked her an apple charlotte once – she had seemed curious about us and we wanted to

Do Something.

We send a card at Christmas.

Perhaps it is London.

People are not friendly in London.

Perhaps I am branded.

Perhaps it is just London.

There are over 12 000 species of bees.

I shut the door and /

MEG: / It is Flora's birthday today. And when she gets back from school we will have a party and a cake and I mustn't get distracted from the list in my Samantha Cameron Smythson Soho diary, specially made in alligator costing £1645. It has a lovely To Do list on each page, which I make full use of. I wrote to Sam Cam to tell her how much I enjoyed the vintage wine section, and she sent a card back. I wonder if David fucks a woman on a Saturday?

OLLIE: There's a kind of fair in Church Street today. Or a fête.

I checked the Stoke Newington page on my laptop yesterday.

It's going to be busy I think.

It doesn't start for another few hours and I'd like to go. I would
Like to go I think and I should Go.

I shower. My bathroom is very small and the ceiling is sloped so
I have to hold the shower by the cord and sit in the bath whilst
I wash. It reminds me of college, of small spaces and having my
knees up by my chin so I feel less

exposed.

I have never had the opportunity for much of a

Reaction

to my body.

The audience has been pretty minimal.

And on the odd occasion when there has been another person
around whilst

I've been

naked

the only occasion actually

it was very dark.

And a bit drunk.

and quite brief.

JUNIPER: I am not very decisive.

I think it is something to do with my generation, perhaps.

That's maybe why we voted in the Lib Dems – I didn't, obviously
– but I accept that it was my generation, so I do take some
responsibility. They sort of didn't say much, didn't say they'd
do much, they kept just saying what they wouldn't do and so
maybe people felt like they weren't committing to anything
really, whilst still being able to bitch about the ones who *were*
doing something. Shit things usually. God, that's such a Lib Dem
kind of thing to say, isn't it?

I got an A in my Chemistry A Level.

I went to South America.

And sort of

Got a job in a doctors' surgery.

Didn't feel like a decision.

OLLIE: I am not a big reader but I read *Lady Chatterley's Lover* once
and flicked to the ahhhhm well thumbed bit that looked like

someone had dropped just that section in a bath and I couldn't make sense of that kind of capacity for

Feeling or

Passion.

or even how on earth it

worked.

My brief

and

strange

experiences with another person in

That Way

have been the times when I have felt as far removed from humanity as I can remember.

Feeling sort of desperately lonely actually, but a

stranger's head inches away and these parts of my body buried in someone else's.

and stomachs rubbing and I'm worried that I'm doing it wrong and I'm suddenly aware that I do not know this person, I do not know this girl whose thighs are rubbing against mine and I'm thinking about it too much but thinking about constellations and galaxies and dark matter within our galaxy being made up of Weakly Interacting Massive Particles which shouldn't be erotic, dark matter definitely shouldn't be sexy and it evidently isn't erotic but I am having sex with her I am having sex with a girl I'm having sex I'm not having sex with a flaccid penis between me and her and her and me and I'm gripping her arms and suddenly aware that she is crying and that

I am

hurting her

and that

this will be something

she Regrets

and that

she has been saying

no

and that

She Looks at Me.

No.

she registers me

and spits.

I worried for a bit for a while

that maybe she had thought I had

assaulted her

had raped her

even

but I never heard anything from her again and can only assume she has forgotten me.

I think about having sex with Juniper Jessops. And wonder what that might be like. I want that to work. I want that to feel right. To pluck up courage to knock on her door perhaps.

But something isn't

I wish I

The heat beats its little fists upon me.

JUNIPER: Can I confess something?

One of my all-time favourite songs in the World is

Gary Glitter, *Wanna be in My Gang.*

I used to march all around my living room singing that song at the top of my voice, being the leader, the absolute Leader of the Gang.

I have thought about making a cake this morning but it does seem a bit pathetic to make your own birthday cake and I have been known to eat an entire cake in one sitting before and given that I feel just a little bit vulnerable, I think I'll just stay on the safe side and not bake a cake.

On the telly they're talking about a Missing Girl so I flick onto Jeremy Kyle, which is equally depressing actually so I just watch music videos for a bit.

I need to head onto Church Street and buy a dress or something for this party.

We live on Manor Road and I like to cycle down Bouverie Road to reach the top end of Church Street where there are some nice not-too vintagey shops. I can't wear jumpsuits and fluorescent

mohair cardigans – I have some – I have bought them in the past because I went through a phase of reading Vogue – I have the Vogue app on my iPhone – and Vogue said that you should definitely be wearing vintage jumpsuits and sometimes I feel sort of pressured to do things, you know? As a woman, probably. It's why I'm a sort of feminist I suppose. But I looked like an absolute tit – sorry – and it didn't feel like me anyway.

MEG: I couldn't find Flora this morning. I checked underneath her bed sheets and in the Den and all over but she wasn't there. She is finding the idea of a new baby
very difficult.

I know because she is hiding more and sulking. She pinches. I have bruises all over my body.

I like Flora.

She is the prettiest thing I have ever made. Apart from a dress I sewed from a vintage Vogue pattern in the late 80s out of black velvet that was the loveliest thing I have ever seen. I wore it with heels that dragged my whole body upwards. I only ever wear heels now. My slippers have a little kitten heel on them. I sleep with stilettos on.

JUNIPER: I think I am going to invite the boy next door to the party.

He hasn't been here long but the people who were there before pretty much set up a brothel in there and – I don't judge – but it was getting to be such an issue that we were thinking of moving, so it feels a bit like fate that he's turned up.

He did put a strange note through our door once and we pinned it to our fridge for a bit. I didn't, Jess did. I did laugh though, I can't lie. I mean, I literally can't lie. Apart from this phase I went through when I was about sixteen whenever I was drunk. We used to go out in Slough and Slough is quite, well, you can imagine, it's a bit of a. Well. I don't want to be rude. But it's a bit of a shit hole. And all these women – these really huge, fat ladies, would go out to the local club – it's called the Sound Exchange – exchanging Sound for Screaming Women and Groping Men and White Awful Noise – and it had *carpets*, we used to dance on *carpets*, what kind of a nightclub has *carpets*? But. Anyway, they'd all be in the club, in the toilets, adjusting their outfits from Jane

Norman – which is the worst name for a designer I have ever heard – and worrying about what they looked like, and I'd just pipe up from nowhere, a sense of panic I suppose – and be like, you look *gorgeous*, you're so *thin*, you've had nine kids? Well you could have fooled me. And I feel bad about it, I do, but I was drunk and when you're drunk it's different rules.

I'll be drunk tonight – I am always the drunkest and I sort of worry about it a bit but you can't too much, can you? Particularly not when it's your birthday party and everyone does it and for all the things out there about how awful binge drinking is – and I do hate that word – 'binge' – it has never made a huge impact on me. I think when you're drinking wine or vodka you sort of get it in your head that you're a bit classy, yeah? – like it can only be binge drinking if you're necking WKDs or Archers and Lemonades – four bottles of wine and you can still say you're a bit *squiffy*, you know?

Anyway. I will get drunk but not as drunk as last year when I got a bit shouty.

I think his name's Oliver,

His name's on the buzzer outside. And sometimes I pick up his post for him. Pop it outside the door. Millie says you shouldn't do that really, that that's not what you do in London, people will think you're nuts.

It's just post, isn't it?

It's just Nice.

Isn't it?

He's harmless enough.

He has nice hair.

Oliver.

And I.

I sort of.

I sort of kept hold of that note he wrote.

Don't get much post – it's all on Facebook and emails now, it's nice to have something that someone has taken the time to write.

And We will be noisy tonight, there are about a million people coming – I have nearly eight hundred friends on Facebook plus

Jess and Millie's friends, so you can imagine the kind of party –
the kind of *noise* it's going to make!

And there will be drugs. Coke and pills and stuff. And. I don't
really enjoy them. But I'll do them. You know? It's like a social
thing. Though it's not that social – Jess screamed at a wall for
about four hours last time she was on acid. But. It' s a party, and
people will be there and people will be taking them and it's nice
to be with people. And it's easier to have sex. With drugs. I don't
love sex. I mean, I love the closeness and that, but it's a bit messy
isn't it? I mean, it's a bit gross really. Limbs against limbs, just sort
of sliding and it's Hard to figure out how it's actually supposed
to work and then you open Cosmo and it's like, page twelve, try
hooking your ankles behind your ears and swinging from the
light fittings, page thirteen, be an independent woman and page
fourteen, hey don't forget to wake your man up with a blow job.

I bet when you're in love it's brilliant.

It's pure dead brilliant.

I put his note between my mattress and my bedsprings.

ROBERT: I have a very high sex drive. Abnormally high actually.
And a high IQ.

Which are my Difficult Areas. My Challenges to Overcome.

It can make me Devious and mean I can be Overbearing.

And Intelligent can take on different connotations.

I taught RE for a long time. Religious Education. And Philosophy
for the A Level students. I was left out of the staff Secret Santa
one year because someone kept giving crucifixes to the teachers
who had been…vociferous about their atheism. They assumed
it was me. Turned out to be Bob, one of the Physics teachers.
He was mortified.

JUNIPER: I shower. I take a long time today, there's no one to bang
on the door today.

The water is hot. I think about Oliver. I think that he is different.
And push my head under the water.

ROBERT: I leave the house at 10am, leaving Holly with June.

Holly is going to wash June today, which is something I normally
do, but Holly does it very tenderly. She holds June like she is

her baby. Her head is very heavy sometimes, particularly when she doesn't want to do something.

Incontinence came late, thankfully, and although there is so much missing that used to be there, she gets very distressed by this, more than she does by her violence or her inability to really recognise anyone. She smiles more at Holly than she does at me.

I love you.

Because I do. I am in possession of the greatest kind of forty-year love.

I leave the house and walk through Abney Cemetery. It is too warm, I have never liked the heat and find it can be a

Difficult

Thing to.

But I have my camera with me, I always have my camera – it's an old Nikon SLR and it is the best thing I have ever bought, the nattiest little thing.

I am good with trees and plants – interested in them and I like to take pictures of the bark and the leaves and flowers. I pin them up in the downstairs bathroom at home, and cut pictures out of books. Shasta daisies and fire poppies, Wickson plums and Japanese knotweed, sweet peas and lavender, gold nectarines and the perfect June Elberta peach.

I'm always the last to arrive. They always say, let's meet at eleven and I get there for ten to, quarter to and they're all there. Assembled. Sombre but smiling. Like funeral guests. Or housewives awaiting guilty husbands. It feels safe. But a little bit dangerous. They must meet half an hour before and I think perhaps one day I will test them, turn up one hour early, but this is a Negative thought and I am able to Identify and Dismiss it.

'Hello Robert, how are you?'

It's always Tom to speak first. He's got *Wolf Hall* in his hand, has done for the last few sessions.

I am Lucky to have a Circle and to have my own June.

I want to be a Good Person.

I want my grave to say he never did it again.

MEG: When Flora was born my heart sped up to six beats a minute. She was nice. She seemed nice. I felt a bit shy. But that we would get on.

I have never been loved. But then I have never loved anything. I don't know that it exists. I think people are terribly good at saying they love things. I can get my head around *'like'*. It's tentative but I see that some things in life are quite nice.

I make the cake batter from scratch.

The eggs are delivered from a farm just outside of London. They are Bright Yellow. I eat one, raw, thinking about the little chick.

I start making a jam for the filling of the Victoria Sponge.

I use the fruit from the garden. Raspberries are a little past their best but I have frozen some so defrost them in the Siemens HB86P672B built-in microwave that cost £1259 plus VAT.

I like making jams or chutneys or lemon curds in the mornings.

I grow blackcurrants and damsons and strawberries and apples, depending on the season.

I roast a pork shoulder I bought from the butchers that I make a particular trip to in Clapham because the *Guardian* says that it is the best. Whilst the cake is baking I watch an episode of Jeremy Kyle with my iPad on my lap. I log onto MSN chat as 'Lucy' a perky twenty-four-year-old from Liverpool and type things like LOL and ROFL and say things like 'have it' and add winking faces for the Dans and Matts and Russells.

I post pictures.

Jeremy Kyle is announcing lie detector results and in the breaks I flick onto BBC3 to watch *Hotter than My Daughter*. Information is literally at my fingertips. I am thinking about the half-moon man as I log onto the Megan's Law website.

He is a little silvered around the edges now, a little blurred in my memory now, a little like looking at a water reflection now.

Was he there?

His skin sort of.

Moved and the Moon moved with it.

What did he want?

A few years ago, Michael and I spent six months in California for his work. We rented an apartment that literally grew out of sand dunes.

The landlord directed us to the best dry cleaners and *grocery* stores and how to track the local *paedophiles* and where to get a decent Gin and Tonic when feeling homesick.

I'm sorry?

Track our local?

Track your local paedophiles.

Megan's Law.

Which was amusing, funny actually, really pretty Hilarious as my name is Megan and it felt like my Law. I couldn't stop laughing. Access to this huge database. Addresses. Names. Photos. Offence. All in a neat little chart.

Suddenly I had something to Do, my own Law to tend to whilst the cakes were rising in the oven or cooling on wire racks, waiting to be iced.

ROBERT: Circles are.

A group of normal, everyday volunteers who meet me to keep me part of a community. Make sure I don't become ostracised. Go to the Edges again. Which is where the problems of course begin. Circles of Accountability and Trust.

Which, I'll admit sound a bit

Hug a Paedophile.

And the. Words. All the Jargon.

Even annoy me, but. You understand, how Important they are?

Circles are for those who are at a risk of re-offending.

And the nature of my

Offence

And the length of my prison sentence

of course

make me a

Prime Candidate, as it were.

MEG: In England we have Sarah's Law.

In England we have a National Unified Hatred for

Paediatricians.

There was that Paediatrician who got assaulted because the locals couldn't figure out the difference between a paediatrician and a paedophile. And everyone panicked. And it's the *News of the Worlds* versus the *Guardians*. I mean, I read the *Guardian* but that happened in *Wales*, not London, I mean it was *Wales* for God's sake, of course they were confused, has anyone ever been to Wales?

Of course not.

But.

These little men with monsters for insides are.

There.

Dressed as Half Moon men perhaps.

ROBERT: I'd like to talk about what I've done.

I'd like to

Account for The Things that I have done in the most Honest and straightforward way possible.

I'd Like to Say Sorry.

But my Circle – who meet me once a week for a couple of hours in a cafe – and once a bowling alley –

Want me to focus on the Future.

There's Tom and Beth and Helen and Scott and Daniel.

And me.

The Core Member.

Which again is.

But it keeps everything clear.

And on Tuesdays and Thursdays I can phone Tom.

And on Mondays I can phone Beth.

And on Wednesdays I can phone Helen.

And on Fridays and Sundays I can phone Scott.

And Saturdays are Daniel's day.

So that If I Am Struggling

If I am Scared

Or If I am in a

Difficult Situation

Tom and Beth and Helen and Scott and Daniel

Can Help
Me to continue to Be
a Good Person.

MEG: I have Four Facebook Accounts.

There's Peter, the twenty-eight-year-old city boy who got married too young and takes too much coke. There's Damien who runs a bar in Clapham and Michael, the forty-nine-year-old married property developer with one child, one on the way and a Woman he Fucks on a Saturday. Okay, so I didn't make all of them up.

Today, I log in as me, Meg, housewife.

Like like like.

My Profile Picture is like all of the other mothers on Facebook. A picture of my baby, of Flora, staring, big blues into the camera.

Events click Profile click Wall click Newsfeed.

Groups.

Remember Baby P.

Click.

Release the REAL identity of Jon Venables.

Click.

Ian Huntley is a murdering psychopath cunt.

Click.

Bring Back Hanging for Paedophiles.

Click.

JUNIPER: I forgot that the fête was going to be on. Fair. Fête.

Feels like a birthday present actually, which is nice.

No one has written happy birthday on my Facebook wall yet, so I write a post – can't believe I'm 24 today!

It's earlier than I realise and when I pop into The Spence Cafe for a Green Tea – I hate it but it's supposed to be so good for you – it's nearly empty. There's a woman in one corner and in the other is a group of about six adults, talking and smiling. They look nice. They're a funny mix of old and young, but I quite like that, I think that's quite sweet and they all have, without fail, kind faces.

I fall in Love with every man I see, do you ever get that?

One of the men in the big group has a copy of *Wolf Hall* on the table and a nice smile which feels a bit like fate and when they break in conversation I ask how it is?

My voice cracks a little and I realise it's the first conversation I've had all day.

…

The book, is it good?

Yes.

It's pretty dense though, isn't it?

I guess so.

I couldn't get past the first chapter.

No?

No.

I'm Juniper. It's my birthday today. That's my Real Name.

Right? I'm Tom. That's my real name too.

He goes back to his group of friends and there's a part of me that's going, really? Is that it? We made a connection, I thought we might get married and have babies, mini Toms and Junipers, spend Sundays reading the papers in bed, between John Lewis sheets with a ridiculously high thread count – whatever a thread count actually is – with the dogs trying to jump up, and the chickens making a noise in the back garden and we'd get up to get the egg and have a cuddle, and carry on renovating our converted Victorian warehouse apartment.

But of course I realise that it would be Odd or actually pretty Mental to say that.

So he says.

Happy Birthday.

By the way.

Oh.

Thank you.

OLLIE: It's better for me to be outside. To get outside.

I haven't had a job since I dropped out of my PhD two months ago and moved to London.

Susan has barely spoken to me.

I am not very good at Self-Reflection but I had felt, instinctively I suppose, that I needed to leave Oxford at that moment.

I had planned to spend a little time in a deep underground laboratory, possibly the Boulby, working on dark matter detection after university.

And my.

I suppose it was my Heart.

People say that when they are talking about Primal things like lust or instinct, they ahhhh attach those kind of emotions to their Heart but I suppose it *was* my Heart

I began to Fantasise

About being a Waiter.

Taking people's orders and bringing them food and having to

Talk to People all day long and it becoming it becoming it becoming

E a s y.

It didn't feel like something to.

Postpone.

And I know that's ridiculous, I do have that level of Self Reflection to know that what happened, what I did was Ridiculous and maybe it was something else, maybe it was other urgencies, maybe it was Other

But now that I am here I can't seem to

Make that

bridge that.

I watch the news.

A police officer is asking for information in a way that makes you think you have information in a way that makes you want to pull up your floorboards.

I do know that it is good for me to be Outside.

I will talk to Juniper Jessops. I will ask her if she likes ice cream and see if she will spend some time. With Me.

I will go to this fête. I will go to this fair and I will make a little bridge in my life in my make-up in my DNA and in my behaviour.

MEG: Remember Baby A Baby B Baby C Baby D and Baby P

Bring back hanging bring back knifing bring back electric chairs and stoning and lethal injections and rape and murder and bombs and

There's Lyndsey and Jane and Karla and Katherine and Ann who all have these babies as their profile pictures and spend their days clicking their heels and their keyboards and

1: Fucking little prick I hope they take his eyes off him in prison and let him commit suicide he should have been publicly hanged

MEG: He deserves to die slowly and in a lot of pain and hopefully be terrified like his victims.

2: Don't forget Maddie!!!!!

1: Die you fuckin dirty murderin nonce if I'm ever in the same jail as you I'll chew your fuckin nose off…cunt

3: Vanessa George Vanessa George evil bitch evil bitch

MEG: Did you hear about that fifteen-year-old girl in Plymouth who sold her little sister for sex

1: She ought to be raped herself sick bitch

MEG: Rape her, I'll get my husband to rape her

1: Fuck it I'll rape her myself

3: Put him in a cell and stone him to death really fucking slowly so he really suffers, shove a hanger up his arse and scrape out his intestines while he's still alive and cut off his dick with a blunt spoon sick fuck sick twisted fuck

2: Want to learn what food to eat for a flatter belly???

3: Die you fuckin murdering nonce if I'm ever in the same cell as you I'll chew your nose off

1: This sick twisted piece of scum is still breathing fresh air, fresh clothes, warmth in the winter a colour TV in his cell and has twenty-four-hour suicide watch, where have we fucked up in this country, if he was in a third-world country he would have been

hung in the street... DIE YOU BASTARD DIE... I hope you have a Terminal illness and you suffer like nothing on this earth.

3: Hang the parents pray for the angel dead child!

1: Bring back Eugenics!

2: She should have her tubes tied. Children bring only joy and she didn't deserve it. RIP at least you're not in pain RIP RIP RIP

1: Die die die die die die DIE DIE DIE

MEG: I hope you're reading this.
I hope you're reading this Vanessa George Ian Huntley Baby P
I really hope you're reading this
I really hope you're fucking reading this. I really hope you're reading this.
I really really hope you're reading this so that I
So that I
So that I
Have
something
so that I
Make an
So that Someone Somewhere is
thinking of me so that I
Am a part of
So that I
Can prove that I
Am breathing?
Just a little?
The doorbell goes.
The baby is kicking.
Hard Now.
The doorbell goes.
I don't want to answer it.
Before we named Flora I checked the Meaning of her name on Mumsnet.

Goddess of the flowers and the spring.

Sounded quite nice. Like she would have to be pretty, regardless of what genes Michael and I put into her.

The brilliance of the Baby Name Finder on Mumsnet is that they also predict what your child will do, what brand of clothes they will wear, where they'll shop and what biscuits they like. I was quite content to know that Flora would be a Boden-wearing Interior Designer shopping at Waitrose for Stem ginger organic wheat frees.

The doorbell goes.

It was just a bit of Fun.

YouTube and Gmail and Mumsnet and Bebo and MySpace and Facebook.

Just a bit.

It is the closest to Exhilarated I have ever felt – it's a bit like some kind of Rage porn, trying to outdo one another, and it gets faster and faster and the doorbell goes and it gets bigger and bigger.

These women, these mothers have so much Rage and I can't quite summon it. I try. I do, I like to try, I am a bit of a try-er and I'd like to be involved so I do try, but it's pretend.

They're bile, their insides are literally made up of fury and hatred, defending their children, being lighthouses to their little boats. And I – I suppose – I am trying to identify my emotion because it is very vague – a shadow of an emotion I suppose – I think what I am feeling is Want. I want to be a part of that somehow. I do want some kind of connection. And I want Information. The Internet has given us a wonderful Right to Information.

The doorbell goes again.

ROBERT: 'How are you doing, Robert?'

Venus is the only planet to rotate clockwise.

'How's June?'

The Chinese invented the wheelbarrow.

'You seem to be struggling a bit today.'

I would like something tangible to hold onto because I feel like I might fall over a lot of the time.

Yes, I am struggling a bit today.

'Why don't we talk about that?'

We could.

We could. Talk about That.

I am struggling under a weight that I cannot describe.

My wife is a Good Person.

My neighbours are Good People.

My Circle, Tom, Beth, Scott, Helen and Daniel are Good People.

I want to believe in an inherent Goodness in Others.

It feels very important to.

But I'm Not. And I suppose we instinctively judge others by our own. Merits.

and I lack an inherent Goodness.

It is like my Body is tied up in knots of Great Astonishing Grief.

My Arms are Grief with what they can't Carry

My Heart is Grief for what it feels

My Head is Grief for what I know I've done

My Back is Grief from the Spineless spine it grows

And my Hands are grief hands are grief from what they've touched and wrung and what misery they have inflicted.

I would like to be Castrated. Literally dismembered.

I want to be Cut up into little pieces and chewed up by someone good, someone like June, someone who has tried and managed to live a Good Life, someone who could eat me up and let me Be in the Bloodstream of something Good. Let me be the Stomach lining for Something Good. Just for those three days.

I have an overwhelming capacity to Feel.

And it Felt like Love. Each and every

C h i l d

Felt like Love.

MEG: I answer the door.

I don't want to but it is incessant. And the Baby is kicking so much I feel as though I have to.

Her face is pretty in my doorframe. I half-think she might be here because Michael fucked her and she has a guilty conscience.

'I'm sorry to disturb you.'

I don't say anything. She looks familiar. Her little white nurse uniform is poking out underneath her sad little pink mac.

'I shouldn't be here.'

Her face is reddening.

'Do you want to come in?'

Surely she hasn't fucked Michael. Nurses are sensible.

'No. I have to get back, I've left her.'

'Sorry?'

'I shouldn't be doing this. I'll get sacked. But. He waved at you. I saw the little bike – the toys – in your garden. You have children? You have children, don't you?'

…

'Yes. Yes. I have a little girl. I have a little girl. Flora.'

…

'He's a convicted sex offender. Mr Elbert. Robert. He's a convicted sex offender. And you have a child. And he waved at you.'

ROBERT: I could not have lived the life I have lived since leaving prison, without my Circle.

My own little community.

My pretend friends.

Butterflies taste with their feet.

I have a second cup of coffee, though I shouldn't.

I tell my Group

'I shouldn't be having this coffee. It's not very good for me'.

MEG: I'm thinking about the half-moon man again.

I do the online Waitrose shop.

Which consists almost entirely of vodka and eggs.

I buy a Diane von Furstenberg dress on net-a-porter.

I want a gin and tonic so I have a gin and no tonic because it is the gin I want and not the tonic. The gin is Hendricks. I have it with the cucumber from Whole Foods that I chop up with the Japanese carving knife that cost £115 and a cigarette because I want cucumber and cigarettes.

I think about that Missing Girl.

About Flora.

About Holly, the nurse.

About Robert.

And the Half Moon Man.

Baby is Kicking.

My shoes are On.

The cake is ready. The pork is roasting.

OLLIE: I'm on Church Street.

In the Middle of a Crowd.

It's Hot and Loud and I want to like it but It Feels a bit like the end of the world.

JUNIPER: I am back on Church Street.

I am wondering a bit about Oliver, thinking how nice his writing is, how thoughtful he seems and the crowd is a bit ridiculous considering there's only a few stalls when I spot him looking a bit flustered over by the Pentacostal Church stand and it feels like fate.

ROBERT: We used to live in Bath.

Bath is beautiful.

It would be impossible to live in Bath now.

MEG: My shoes are on and I'm out of the house.

The sky is blistering.

It looks ready to Burst.

The bins haven't been collected and it bothers me. Like a twitch to the left of my spine.

I had forgotten about the fête – or the fair – and so it takes a little longer to get through Church Street but people move for me because of my Bump and it is very Middle Class around here.

There is a man shouting poems.

A little girl holding a bunch of red balloons, with ribbons in her hair.

And a young boy Man with curls who I Smack straight into in front of the Pentacostal stand who I can't quite

Boy? Man?

Place and
Oh

OLLIE: Sorry /

MEG: / No, I – /

OLLIE: / I didn't /

MEG: / No, it's /

ROBERT: / Outside the streets are busy now.
I'm wondering about June now.
The pretty young girl who talked to Tom
who blushed
Is hovering outside.
In the distance, further up the street is a bunch of bright red balloons
and holding them tightly by their ribbons
is a little girl.
The heat is too much
It is too much.
I am wondering about June again.
We talk a little more about my French class and the Garden Centre that I help out in on a Saturday afternoon.
We talk a little more about June, but not too much because she wouldn't like it.
We don't talk about my
Past, so much these days.
It is counter productive.
There was a Missing Child on the news today. How do I feel?
Sad.
Hopeful.
But Relieved. Mainly I feel Relief that it wasn't me, that I know that it wasn't me.

MEG: I'm whirling past the boy in a slight daze – my heart crept up to five beats a minute, just for that minute and he looked straight through me. Barely even registered me. The baby is kicking.

There's an open-mouthed girl with her hand on a red bike. I recognise her from the doctors' surgery, I think, I think she has touched my belly and sat in on my ultrasounds and tried to scare the life out of me quite literally with 'You're quite swollen Mrs Daniels, you do know that can indicate pre-eclampsia? And if your skin is itchy you must tell me as it could signal cholestasis and all your headaches mean you've actually got high blood pressure and will probably die with your new baby half-way out of your cunt up to its shoulders and they'll have to scrape it out of you using one of your Nigella's own turkey basters.' Or something to that effect. She was very jolly about it all. Another doe-eyed.

I stop to catch my breath.

OLLIE: I am thinking about last night again, though I don't want to.

I am thinking that I should go back to the house with the Budleia and the Ivy.

It had been too much – I had gone too far. Before, it's been easy enough to alter my IP, erase my hard drive, reconfigure or reprogram or.

But it was too much

This time.

Frantically, tapping and typing and clicking and my sweat is all over the keyboard, my trousers a little way down, the cool of the garden chair at the foot of my bed beneath my bare legs and I don't want to cry, I just want it. Gone.

The pregnant woman who nearly ran into me, hovers nearby for a minute or so, something like shock on her face, before hurrying on.

But I'm not really.

Registering her.

And the House with the Budleia is gone from my head

Because.

There is a girl. With ribbons in her hair.

There is a girl.

With lovely ribbons in her hair and it has never before occurred to me that ribbons could be lovely.

I am in the Crowd.

And pushed up against other bodies, other elbows, other shoelaces, other armpits, other eyes, I am suddenly feeling more Human and more Monstrous by the minute but I suppose that's part and parcel really and it doesn't matter because there is a girl and I am not Reflecting upon Myself, I am

Positively Humming.

It's seventeen minutes past two as she walks into Abney Cemetery Park.

ROBERT: Beth and Helen and Scott and Dan and Tom are a bit concerned this time.

And when they are Concerned they have to report back to the police.

We arrange to have another meeting for two days' time. This helps. And I am Lucky.

The pretty girl is still outside the shop. She's just looking at things. The girl with the balloons is gone but she has let go of one of them. Outside the cafe I stop to take a photo of the sky.

JUNIPER: I lose Oliver for a moment in the crowd.

I can't see where he's gone and I realise how mad it is that we haven't ever spoken. How lovely he seems. How I like that he gets letters with the Oxford University stamp on them. And that I can't find him on Facebook, but he does come up on Google in an article about stellar evolution and discoveries.

Which just makes me

Tingle.

There's a little picture of him on Google Images – my generation is just very good with technology – with a group of people, and he looks ever so lovely and just a little bit sad and his face is the only one within a crowd that I really

Register

I wonder what he thinks of me.

I get distracted by a red balloon going up into the sky like a red apple. A girl, about six or so with yellow hair and red ribbons had been clutching a bunch earlier but I can't see her.

A pregnant woman who comes into the surgery sometimes stops and stands beside me to watch the parade that's starting up. I still need to buy a dress.

She looks a bit flustered and her bump is quite big.

Are you okay?

MEG: Sorry?

JUNIPER: Are you alright? It's hot, do you need a seat, or some water? I'm a nurse, I'm not just being odd.

MEG: No.

Thank you.

JUNIPER: *She's* being a bit odd. But then pregnant women are allowed to be, aren't they. She's having a boy, I remember from the scan, though she didn't want to know the sex, and I've always thought how mental that actually is – to have a teeny tiny penis growing inside you.

One of the men from inside – not Tom, but an older man steps out of the cafe and takes this really amazing vintagey camera out of his pocket – they had ones a bit like it in Urban Outfitters but he doesn't look like an Urban Outfitters kind of guy. He has a big coat on – in this heat – and the sleeves are too long and he looks ever so small.

He reminds me a little bit of my granddad, not just because he is quite old but because he looks so

Very

Nice

that I want to cry.

He takes a photograph of the balloon in the sky.

MEG: I want to move on but the baby is kicking like mad. The smiley girl has stopped asking me inane questions which is now quite irritating because I would quite like some water and a chair but can't ask.

A man comes out of the cafe behind us and a parade is starting up.

I am Dizzy.

I can't quite focus, my eyes can't quite focus on him

I think about the half-moon man in my garden again as he takes out a camera and shoots at something.

There are children in the parade. Tiny little bobbing humans, giggling and swaying like miniature drunks.

My Heart is beating again.

He could have been aiming at the sky. At the lost balloon in the sky.

Or he could have been

taking a shot

of a child.

My eyes lock with his.

The edges of him move to a shimmer, in time with the edges of the sun.

The point at which his skin stops and the sky starts blurs, wavers and blues.

He is half of a Moon.

It's the Man from over the Road, my Baby is Kicking and I think about what the Nurse said and I

I reach out for something, my hand grabbing at the Red Mouthed, Red Biked girl.

JUNIPER: Are you okay?

MEG: My mouth is very dry, suddenly full of dusty and very forgotten love letters.

I can't stop it from gaping.

The man reaches to help me.

I can't see him. He is giving off a light that neither my eyes nor heart can manage.

ROBERT: Are you okay?

JUNIPER: Are you alright?

MEG: I spit.

And push through.

I turn around, a new beat to my steps, my Heart, a new purpose.

OLLIE: My skin is very dry. It's peeling as I step into Abney
Cemetery, my Heart pumping.

I wanted to throw my laptop out of a window last night to stop
it from.

but I am not the most impulsive person

stop it from happening again

but that seemed like a very dramatic thing to do.

I got on the 106 to Finsbury Park instead and then on the Victoria
line all the way out to Brixton.

I should have taken a hammer and Smashed it.

Or some Petrol and set it on fire.

Or out to a Tip so it could just be

Crushed.

How do people commit crimes – it takes such a lot of planning.
I Panicked.

My palms get sweaty quite quickly and my Hands tend to shake
in the most mundane, everyday sort of situations anyway so I
look like I'm having a fit as I wonder around Brixton, my laptop
under my arm and all of this liquid, all of these seas pouring
from my face. I don't know Brixton, I don't even know my way
around Brixton and I feel like I might fall over as I get back on
the tube, get back on the tube, my laptop still on my lap and
get off at Finsbury Park with nothing with nothing with nothing
Achieved.

I get back on the 106. It's busy. I am soaking.

I get off two stops early. Three stops early?

At the Posh End of Manor Road.

I hear Sirens. Lots of Sirens.

Panic

Now

And just Drop the Laptop into a Bin in the Garden of a Redbrick
House covered in Ivy and Budleia.

And I Duck

In and

Push my back along the wall until I'm into the back garden which
is overgrown and thick with plants.

Sirens going past me, of course, of course of course they're not
for me.

It stops.

My Heart slows

right down.

I edge along the wall. I curl up into a ball – which has never
sounded quite right until now.

I push my fingers into the earth.

Look up.

White Dwarfs.

It's only when the woman in the garden makes a noise that I
see her.

She's stood underneath the full Hay Moon, her red nightgown
like a poppy, her red mouth like a rip in her face.

The garden is yellow. And violet. And my Heart is up again,
making a beat that sends a smack to my brains, rattles my skull.

For a moment, she looks at me.

Startled, I think.

She rubs her eyes.

And I run.

It's only when I'm back in the flat that I realise I'm not wearing
Gloves and that.

I am a Good Self-Comforter.

I watch the Stars.

And I slept.

JUNIPER: I stop in at Whole Foods and buy some quiches and
some cakes. I can't really afford it, I definitely can't afford the
crisps and guacamole and houmus or the organic prosecco or
the little *vol au vents* but it is only your 24th birthday once and
there will be lots of people there and I can never decide what
to buy so often end up buying everything.

I get the party rings from the big newsagent on the High Street
that I like to go to because he is quite famous around here for
not selling porn. There are lots of photos of him and Diane
Abbott beaming. He still sells *The Sport* which is just porn with

headlines really but we all sort of ignore that because at least he is Doing Something.

I wonder about the Woman, the pregnant woman who had stumbled and left so suddenly. She seemed to know the man with the camera, she looked at him in such a way and for a moment I thought she had spat.

Are you okay?

His face was the colour of pavement.

Are you okay?

He was very close to tears.

Are you okay?

ROBERT: Thank you.

JUNIPER: And that was it. He was gone.

I need to get the houmus and the vol au vents in the fridge and I can come back out to buy a party outfit later. I could cycle back along the High Street but it is such a lovely day I lock my bike up and decide to walk home through Abney Park.

ROBERT: I walk back along the main roads, thinking of June,

focusing on June.

The pregnant woman who lives over the road had looked at me, Startled. Had known me.

More.

Had Spat.

It must be Burnt upon my forehead.

I am on Edge. On a Brink. I go past Stoke Newington Station thinking of train tracks.

MEG: I am back on Manor Road, past the Station.

The Baby is Thumping at the Walls of my stomach.

I think of Flora.

Home from School.

I need to get back.

My Heart has started up for the first time in my life. It feels like my Life is Starting, like something is Happening.

OLLIE: She is sitting on a bench in a thicket of trees.

I'm not thinking of Dark Matter or Stars for the first time in a long time.

She Smiles.

Her Heart Knows my Heart for a brief Moment. She isn't afraid.

Hello.

Hello.

I'm Ollie.

I'm Rosie.

Rosie.

I feel like all of my organs are on the outside, no longer contained by my skin.

Which is what Love is. I suppose.

I want to make her feel Warm and Safe. I want to take the ribbons from her hair.

I am sat next to her.

I untie one ribbon

She is still holding the balloons.

JUNIPER: My bags are heavy.

It is very easy to get lost in Abney Park. But I quite like it. There are hundreds of graves and statues and trees and flowers and it's easy to wind up roughly in the Middle of Nowhere. It doesn't feel like London. In a Good Way.

It is deserted. All of Stoke Newington is at the fête.

I feel like the only person on the planet.

I check my phone. Check my emails. Check my Facebook. And put it back in my pocket for one little minute.

ROBERT: As Holly leaves she says, 'Goodbye Mr Elbert.'

Something like singing begins near my Heart. Her cheeks are pink, her eyes moist.

June is like a baby again. She can talk. But she doesn't make much sense. But I understand her.

She lifts her arms to me when I come in from outside and this gives me an Unspeakable Joy.

We drink lemonade.

I tell her about my day. About my meeting. And the red balloon.

I do not tell her about the spit. Or that my Circle will speak to the police about my progress.

Because

I am so very Lucky.

MEG: I am back in the kitchen, underneath the windows.

The sun is coming in and making everything boil.

The kitchen smells of pig.

I run the Japanese carving knife that is wet with cucumber under the tap.

My Heart is positively racing as I go to the living room and pull back the curtain.

OLLIE: We sit for a few minutes.

I am Excited.

But At Ease with her. This isn't like

with the internet

with the pictures

This is Love, this feels like Love.

It isn't Difficult.

And I am in Charge.

I felt her Heart Beat.

There are 12 points on the body to measure the rate of the heart from.

I felt them all.

Her little heart, her little proofs of life all over her body.

Her wrist, her neck, the inside of her elbow, behind her freckled knee, her abdomen, her groin, her temple, her jaw, her forearm, her foot and the apex of her heart.

Her actual heart!

Racing.

I looked into her big big eyes. And found one hundred moons in amongst the blue.

My hands traced her face, her cheeks, her nose, her forehead.

She copied, hooking three fingers into the inside of my mouth, my cheek like a child. I copied the gesture, my fingers finding the warmth and the wet of her tongue, the small of her teeth.

I want to tell her that she is like SN 1572 to me. A Supernova. A New Star from which the Heavens will be Mapped around.

But I tell her she is wonderful.

I tell her she is Kind.

Kind to let me sit with her and Talk with her.

We talk.

She sits upon my lap.

And holds my hand.

And I tell her she is lovely.

Lovely to let me kiss her cheeks that are so pink.

And she kisses my nose back with a little noise.

And I tell her she is like a Lady of the land.

Like a Lady to let me put my hand upon her leg.

I go Quicker.

Like a Princess to let me put a hand over her knickers.

Like a Queen to let me go into her knickers and press upwards towards the bone.

She lets go of the balloons all at once.

I have found Love.

JUNIPER: I have always believed in People.

The trees are making shapes with the sun. Like late lazy mouths wilting a little after too many kisses.

Love takes a little longer when it is worth the wait.

Life takes a little longer to get going when it is worth the wait.

I think of Oliver again. Of how nice he looked in the sun. Of my party.

Just ahead of me a bunch of red balloons goes up like a flare. Birds gather and fall away as the little balloons float upwards.

MEG: I am not silly.

I am not mad.

I Am

lonely. I do Feel Lonely, that is a feeling I can positively identify as I watch Robert Elbert lift his wife's large body up towards his and then down into a soft chair by their window. She looks at me. She wasn't always like that, I don't think.

When they moved in, she baked me something with plums in. Or oranges or strawberries perhaps.

They send a card sometimes.

He has big writing with loops in it.

But they have been quiet. Sort of hidden. It must be important – necessary for him to be so.

I think of the websites. Of little faces on big newspapers, getting smaller.

Of what he must have done.

My Heart is fast. But Steady. There is a quiet around my ribcage as I step into the hall, barely realising that the knife is still in my hands.

ROBERT: I have bruises on my stomach from where she hits me.

I would Like to think that it is the Illness.

But I feel that she knows me. And that, like when she screams that she hates me, it is because of what I did to her and to us and to children.

Some days.

When bridges look like they lead the way to a Quiet and a Home

I want to roar

I'm not doing

ANYTHING FOR YOU

ANYMORE.

but I don't.

I don't deserve her and she didn't deserve what I did.

I wonder if I will feel something like silence in my Heart one day instead of this great Mass of Feeling that has meant so many different feelings over my life and is now mainly Grief and love for June.

MEG: I have resigned myself to never feeling Love.

When Flora died, and I do know that she died, I just have a need to pretend and fuck anyone who cannot indulge that – I wonder if I forgot everything. In my memory of her she is nice. And quite funny. And kind. But I don't remember loving her. I remember

wanting to Make something to Love because I hadn't found it anywhere else, but I don't remember ever experiencing it.

She's like a disturbance in a mirror. When I think of her as dead she's

Tied up with blue string like a parcel

Dressed as a spider

Covered in feathers

Enormous and Tiny

A crescent Moon

The crackling on Sunday pork

and a little girl who doesn't look like her. Covered in lights.

She is inexplicable.

And I find these tiny pinch marks on my body that are the right size for her hands. I don't remember if she pinched.

It might have been easier if she had been molested and murdered. Which you aren't supposed to say. But there was no one to be angry with. So I didn't feel angry.

She slipped. Slipped on a wall.

I wasn't there.

I took a shit in an envelope and put it through the door of the Mother who was there.

So I suppose I was angry.

I don't remember.

So I suppose I did love her.

I don't remember.

OLLIE: I am heady. Dizzy. Hands a little quicker than I would want.

She has tracks like snail marks upon her little cheeks.

Her mouth moves, divides and multiplies beneath my hand, her face is wet.

Life has altered immeasurably.

JUNIPER: Abney Park looks beautiful today.

There is a little sadness that scratches beneath every so often.

I try not to just go through the motions.

I step into the clearing.

And see Oliver on a bench.

I will ask him, I decide, I will ask him with all of my Heart, to come to my party.

Oliver.

With a little girl?

MEG: The door is open. I must have forgotten to close it.

The radio is on

The knife is in my hand

I have forgotten my shoes.

Flora's bike is pink like a smile in the green of the garden.

A sprinkler is on in the garden next to ours.

The lid of the bin is open and a laptop sits on top of the grass cuttings, but I'm thinking of Flora and the baby and of Robert and his wife with the knife in my hand and my feet on hot tarmac.

The baby is still.

The pork will be ready.

My feet reach the grass beneath their door.

I can see a moon behind the sun.

ROBERT: The doorbell rings.

The right lung of a human is larger than the left one. This is because of the space and placement of the heart.

I can feel a light humming in my cheek.

The doorbell rings.

I love you, I say, waiting for the silence.

And then.

For the first time in five years.

Just Once.

Moving into the quiet for four beautiful moments.

I love you too.